Tobago Colouring Book

It is well documented that, for many people (adults and children alike), colouring is a therapeutic, stress-relieving pastime.

What could be better, then, than colouring pictures of the beautiful Caribbean island of Tobago? Imagine yourself soaking up the sun on a palm-fringed beach, watching incredible hummingbirds, or enjoying a rum punch as the sun goes down.

Unlike most other colouring books which are usually filled with whimsical and cartoon images, mine are full of real pictures.

In this case, the colouring pages were created from photographs I took during our first four-month stay in Tobago. Within this book, you will find images of some of the best beaches to be found here - Big Bay and Little Bay in Castara, Englishman's Bay, Pigeon Point, Parlatuvier, and many more. You will also find pictures of Stonehaven, Little Tobago and places on both the windward and leeward sides of the island. There are drawings here to inspire you and get your creative juices flowing!!

Grab your favourite pens or pencils and let your imagination and creativity run riot. I use high quality fine-tip felt pens for the details, and coloured pencils for the larger areas, but the choice is yours. Some people like to put a water colour wash across the whole picture before they begin. It's your creation. It's up to you!

Cut out your finished work and display it somewhere as in inspiration to travel further for longer, or as a reminder of places you've already been to.

Keep in touch with me at Happy Days Travel Blog or on social media:

@happydaystravelblog @happydayswriter

Show me your creations, follow my travels, and tell me about yours!

Copyright © 2019 Happy Days Publishing - All Rights Reserved. Further information from https://happydaystravelblog.com

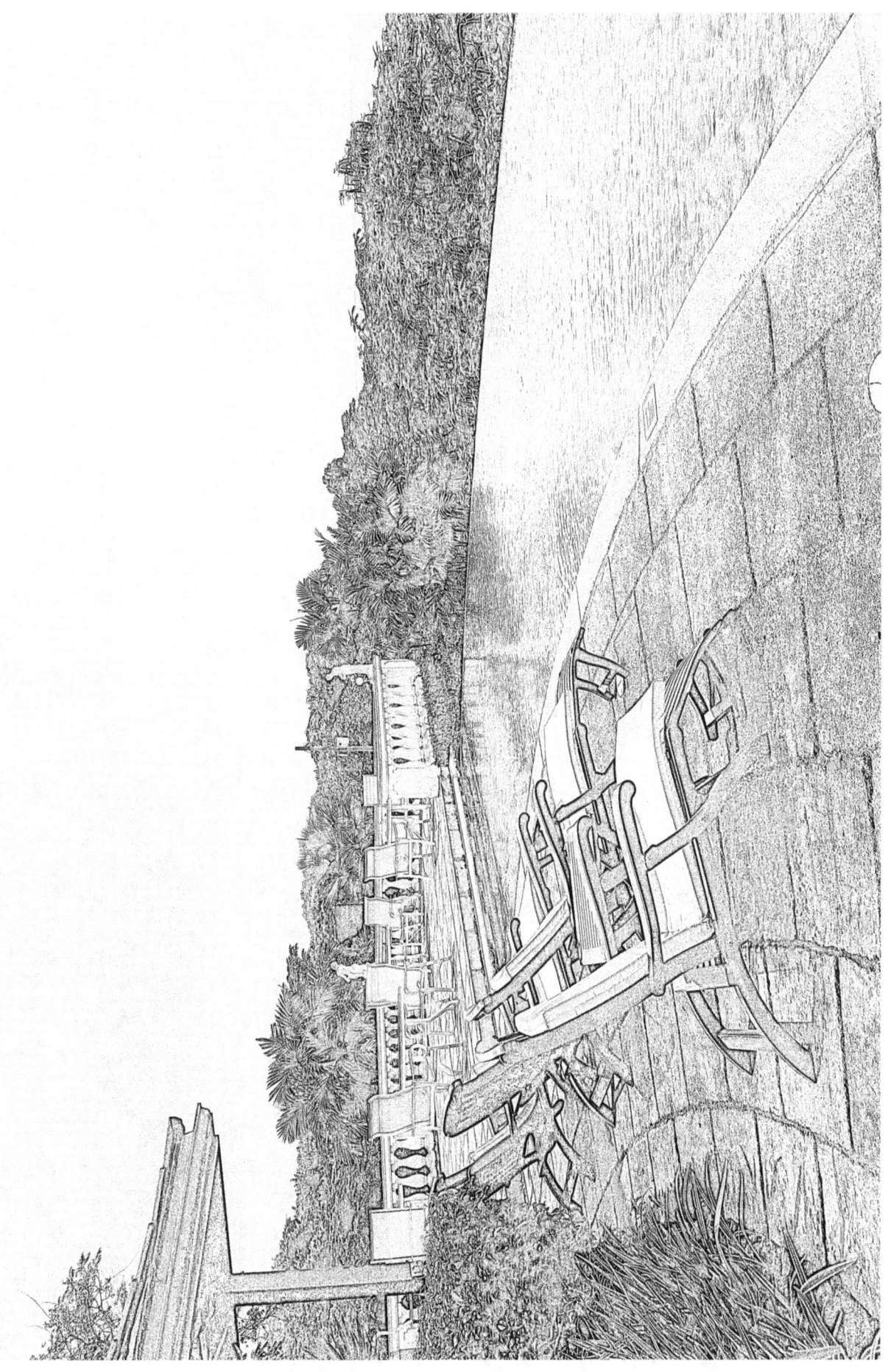

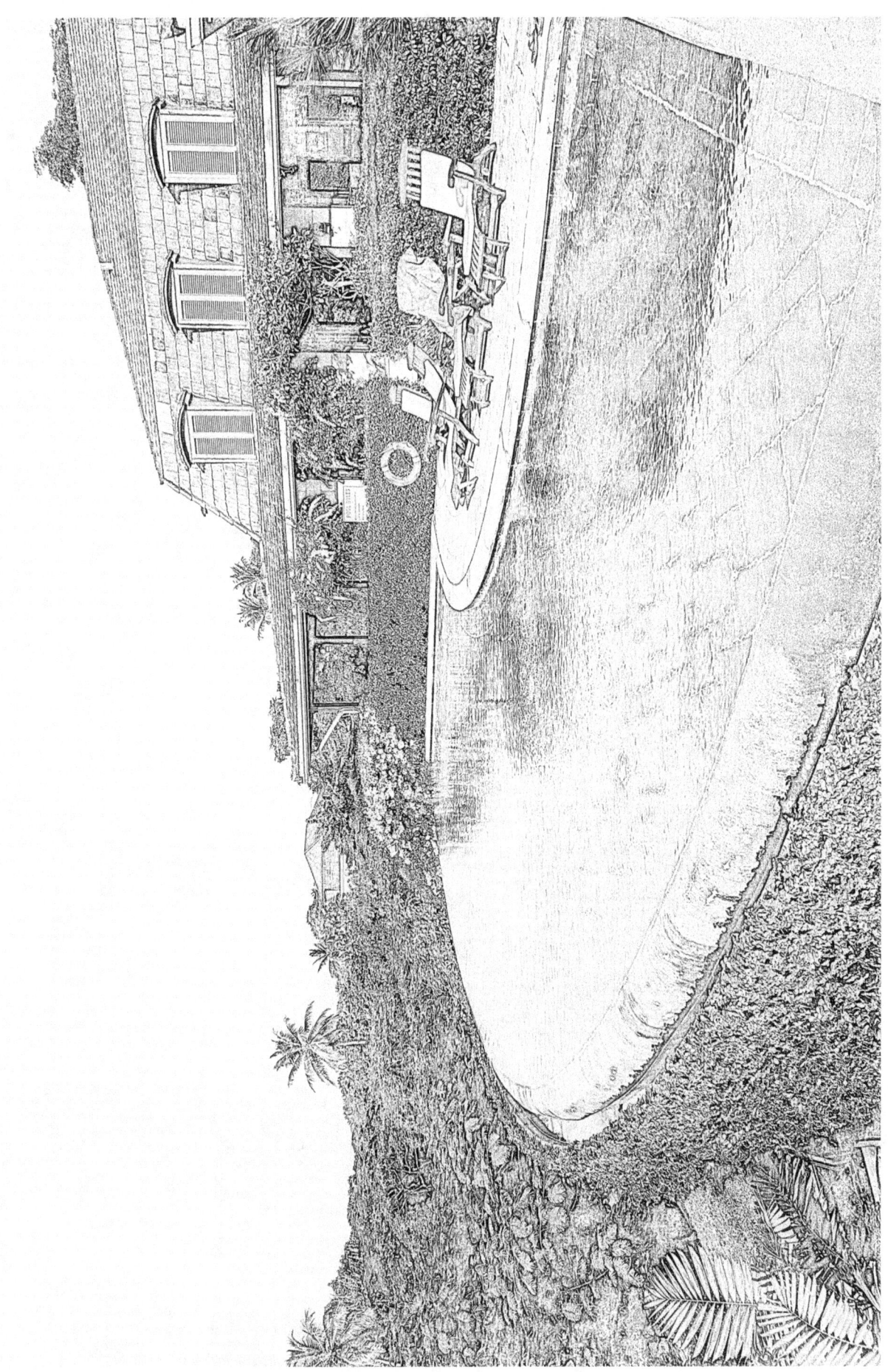

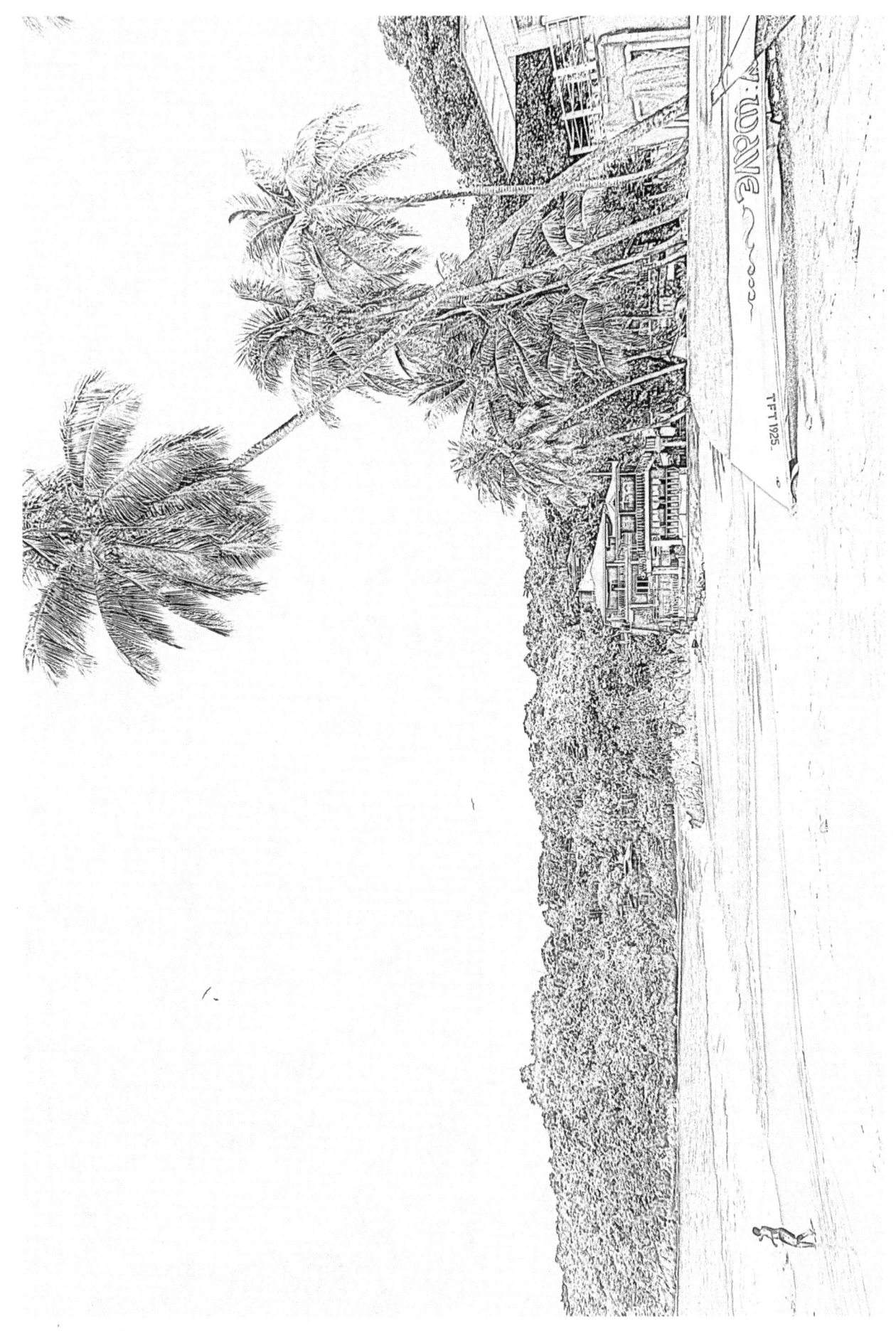

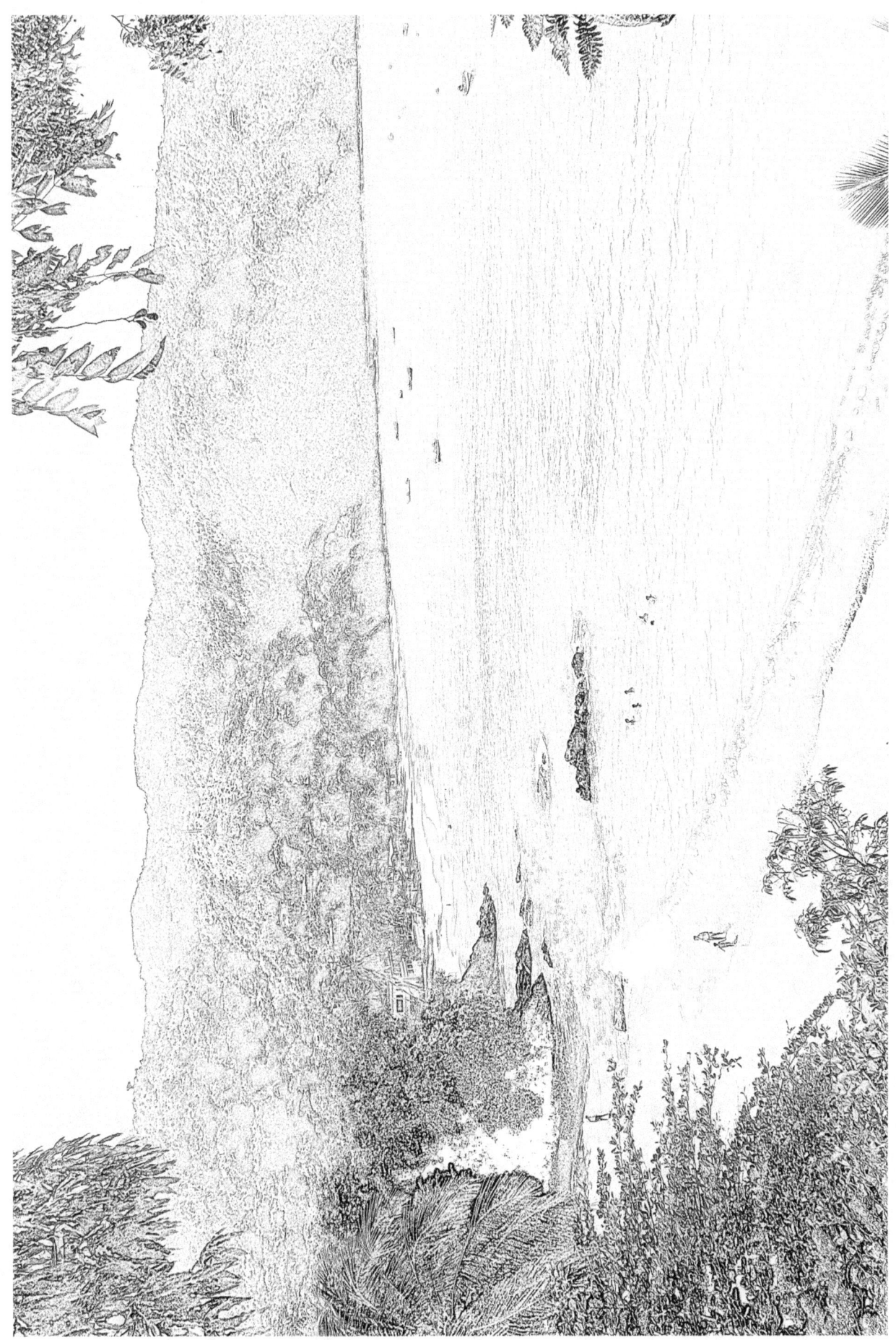

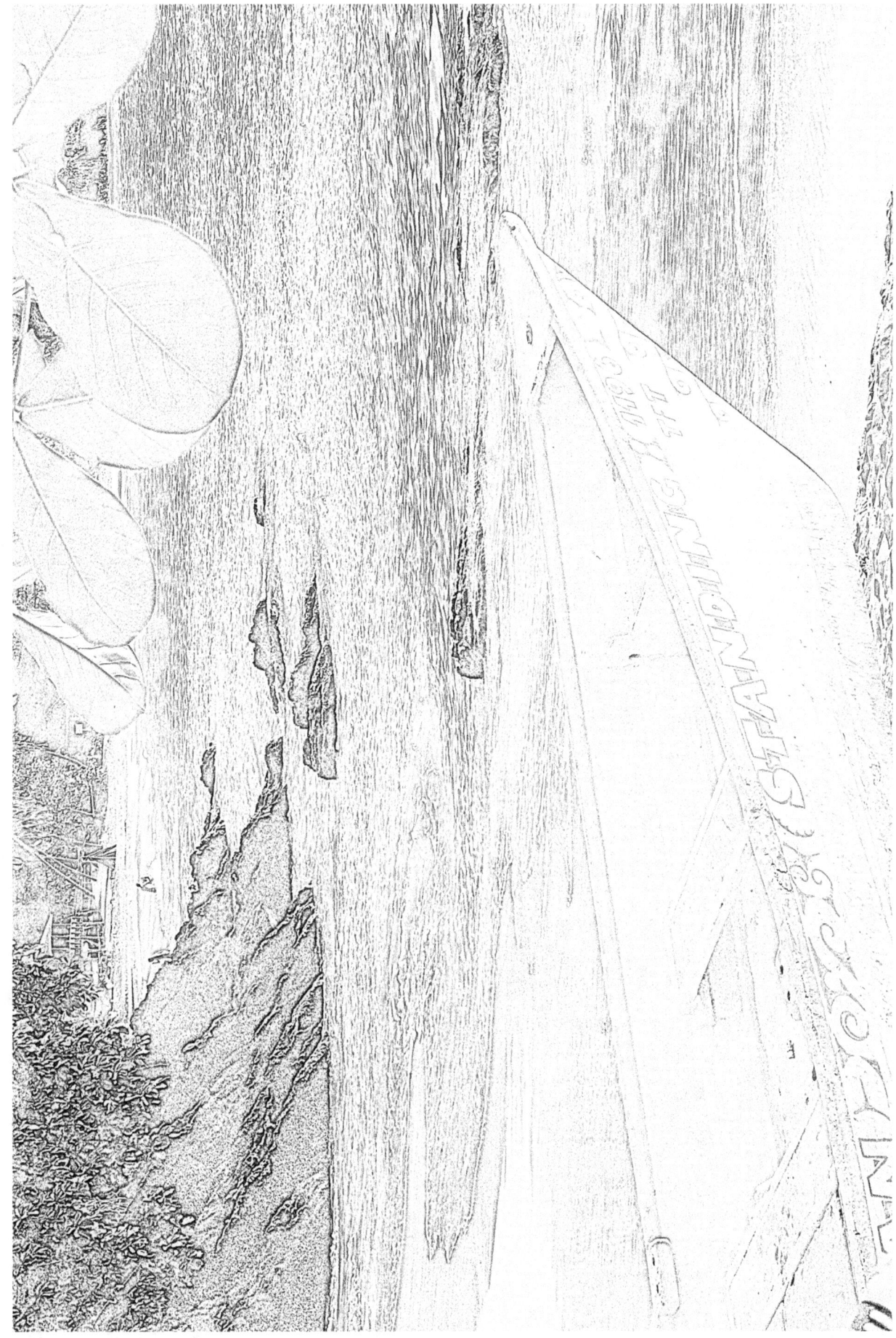

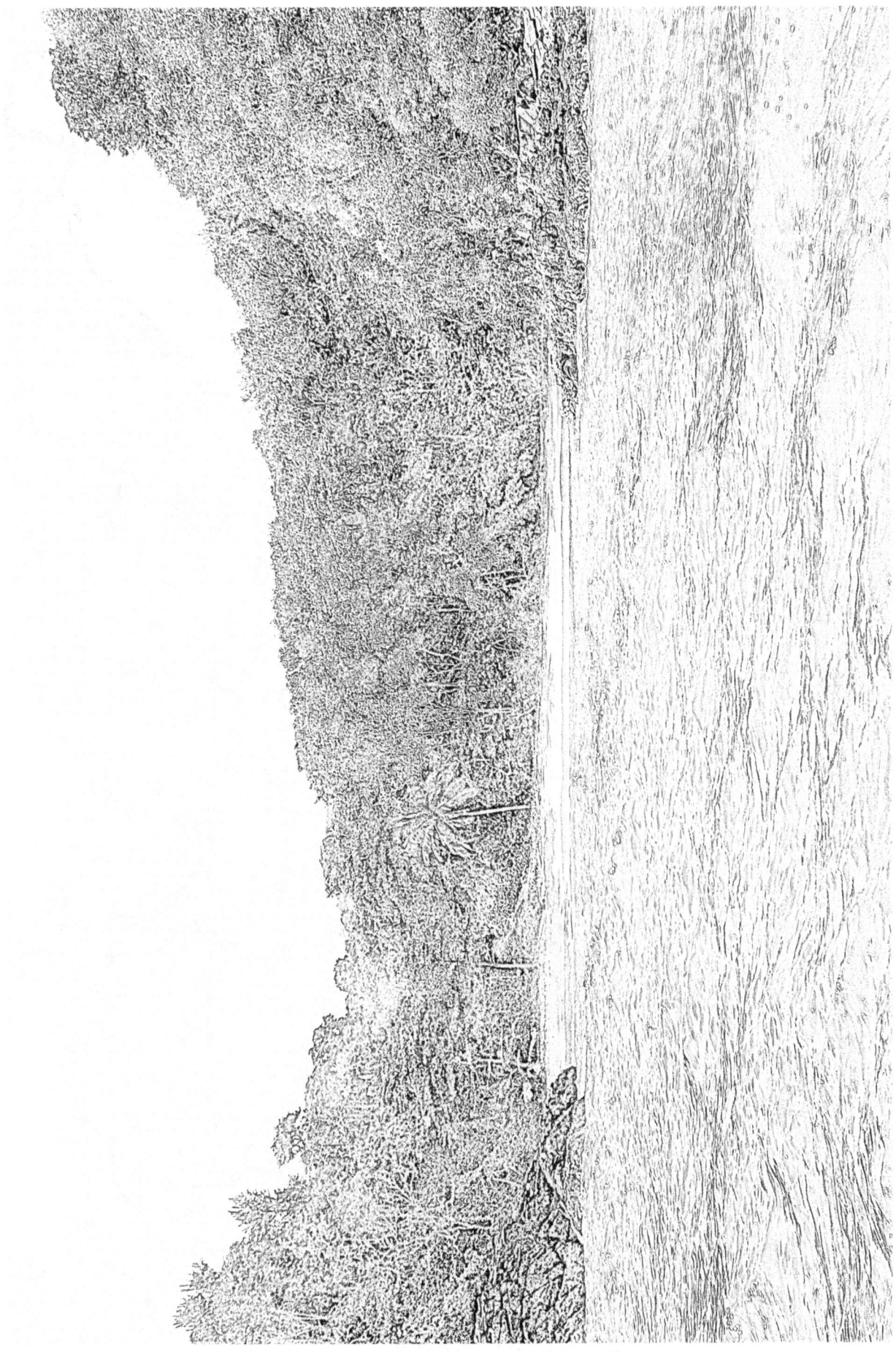

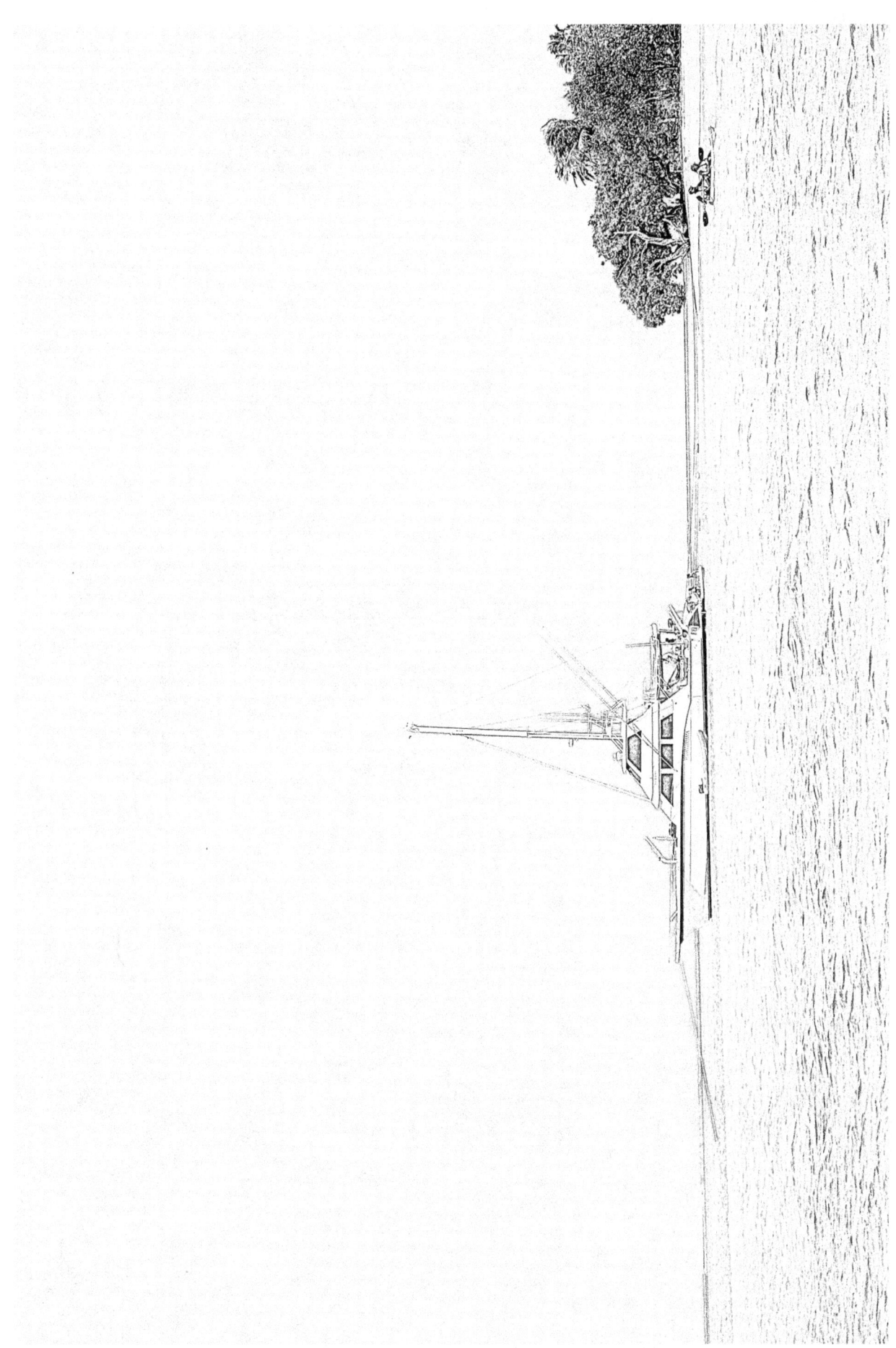

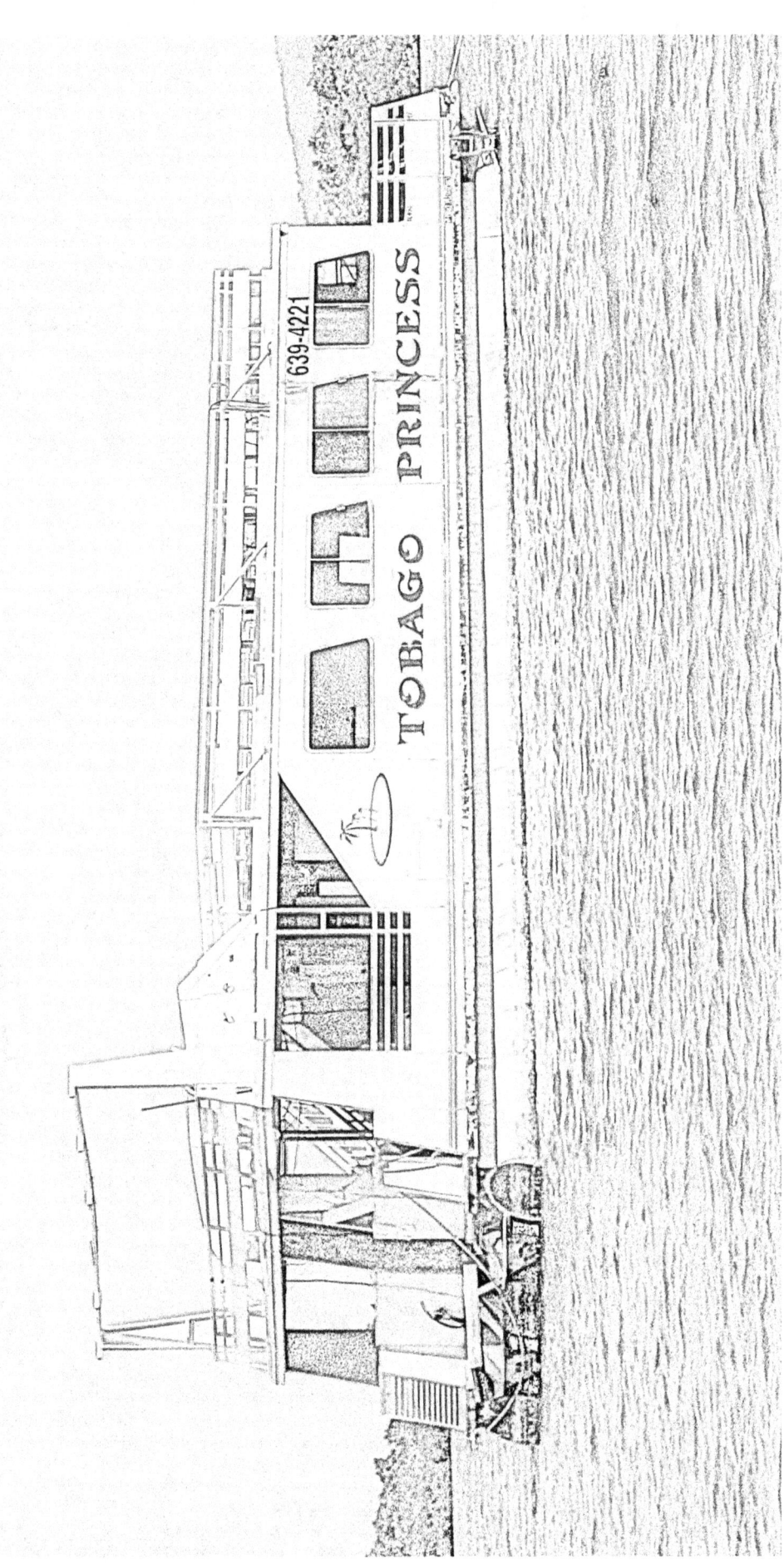

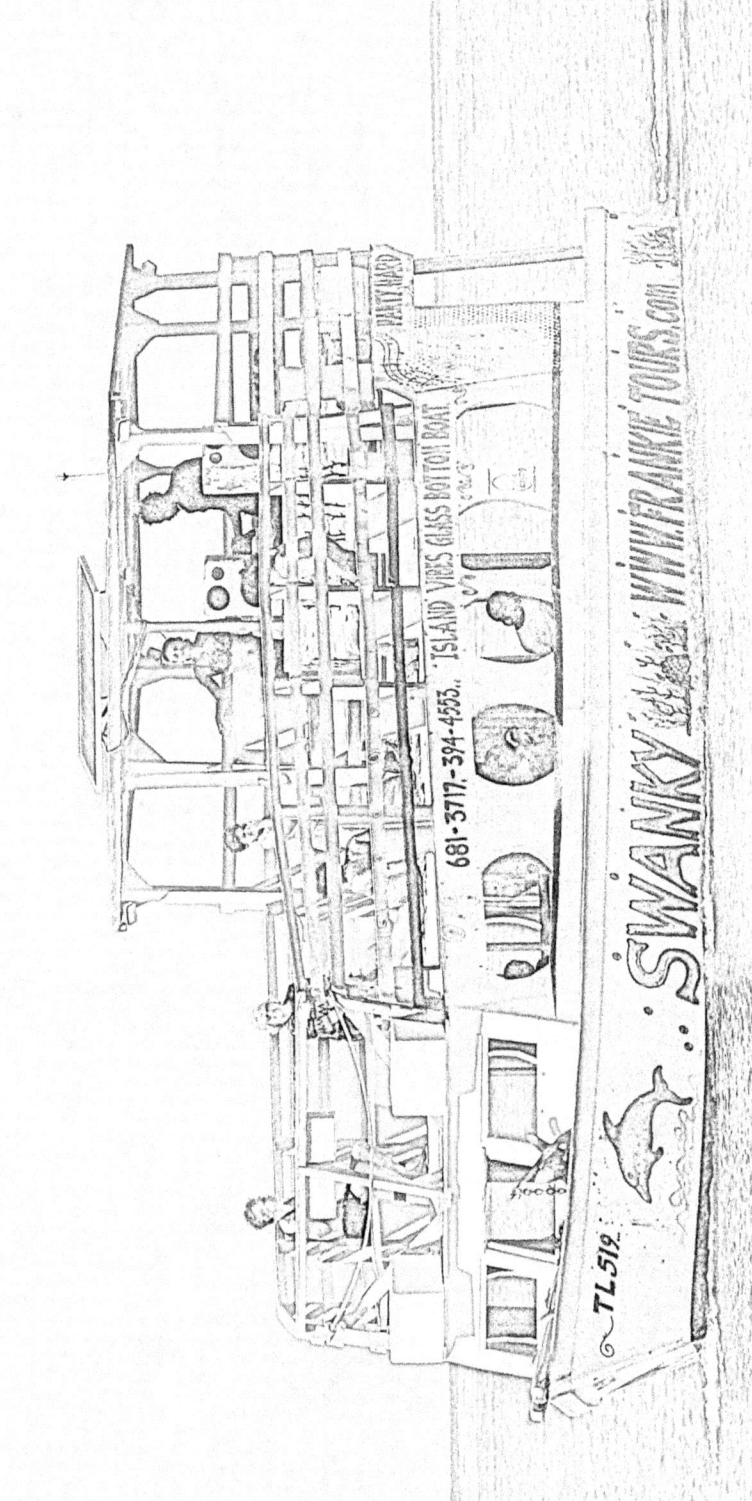

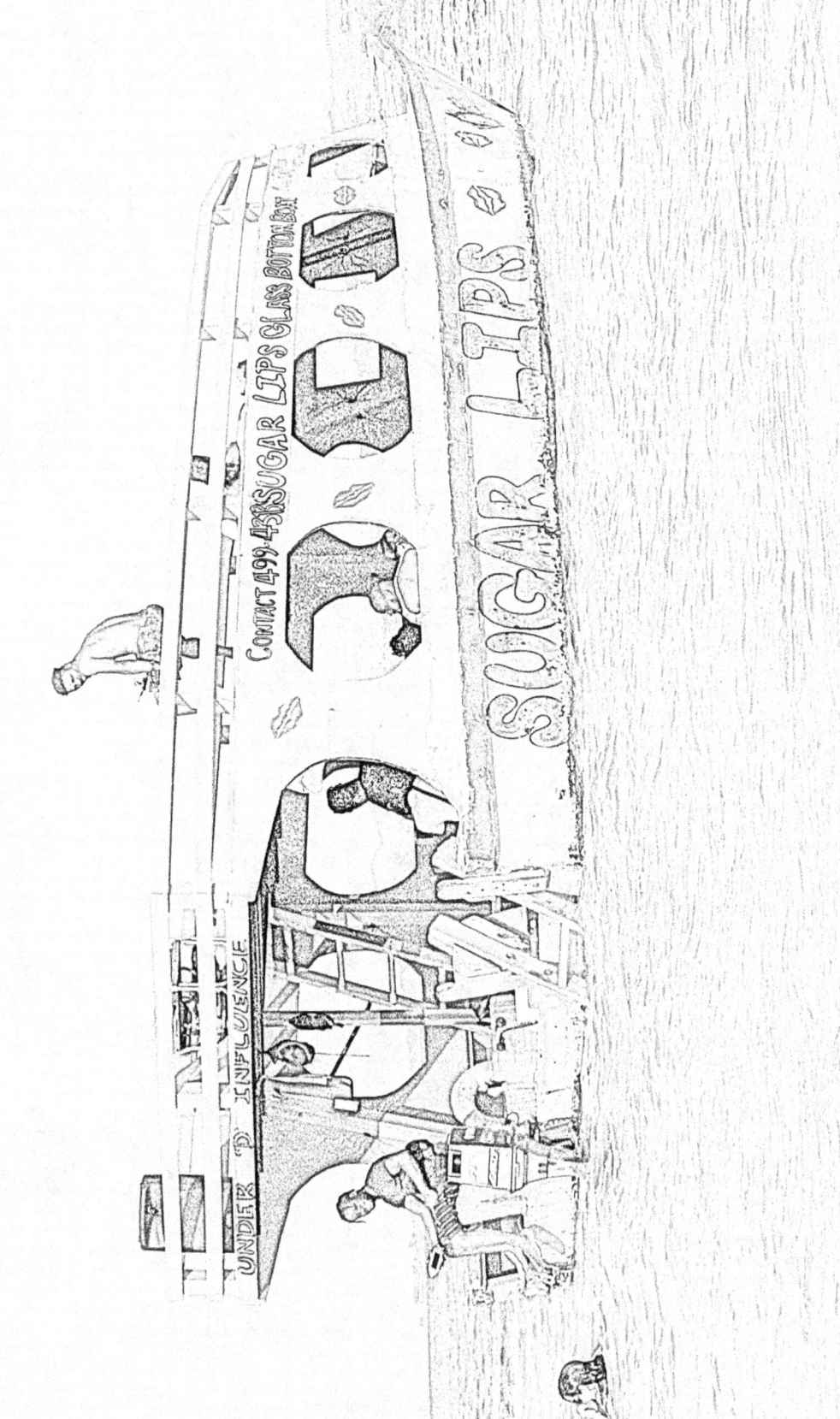

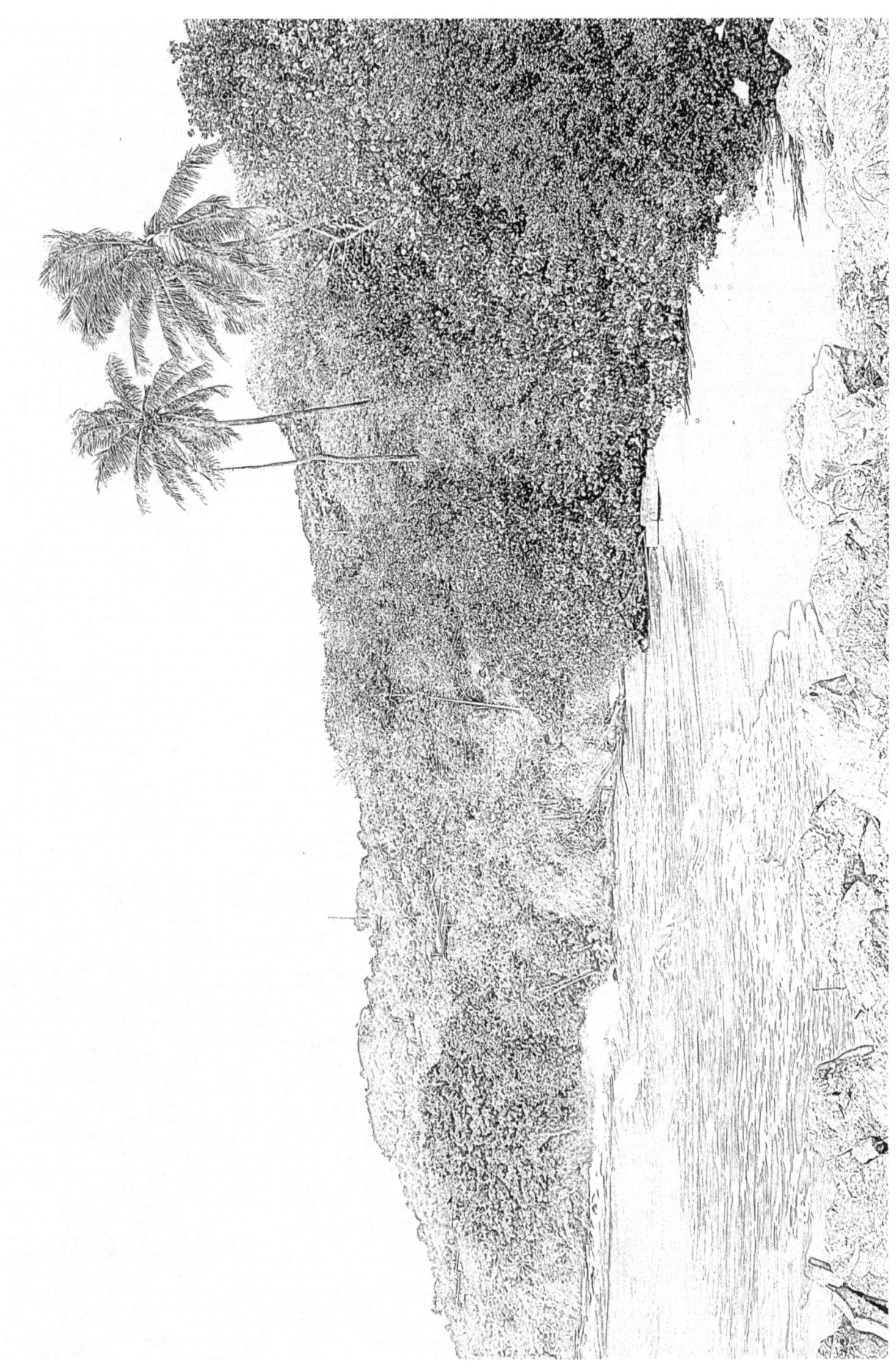

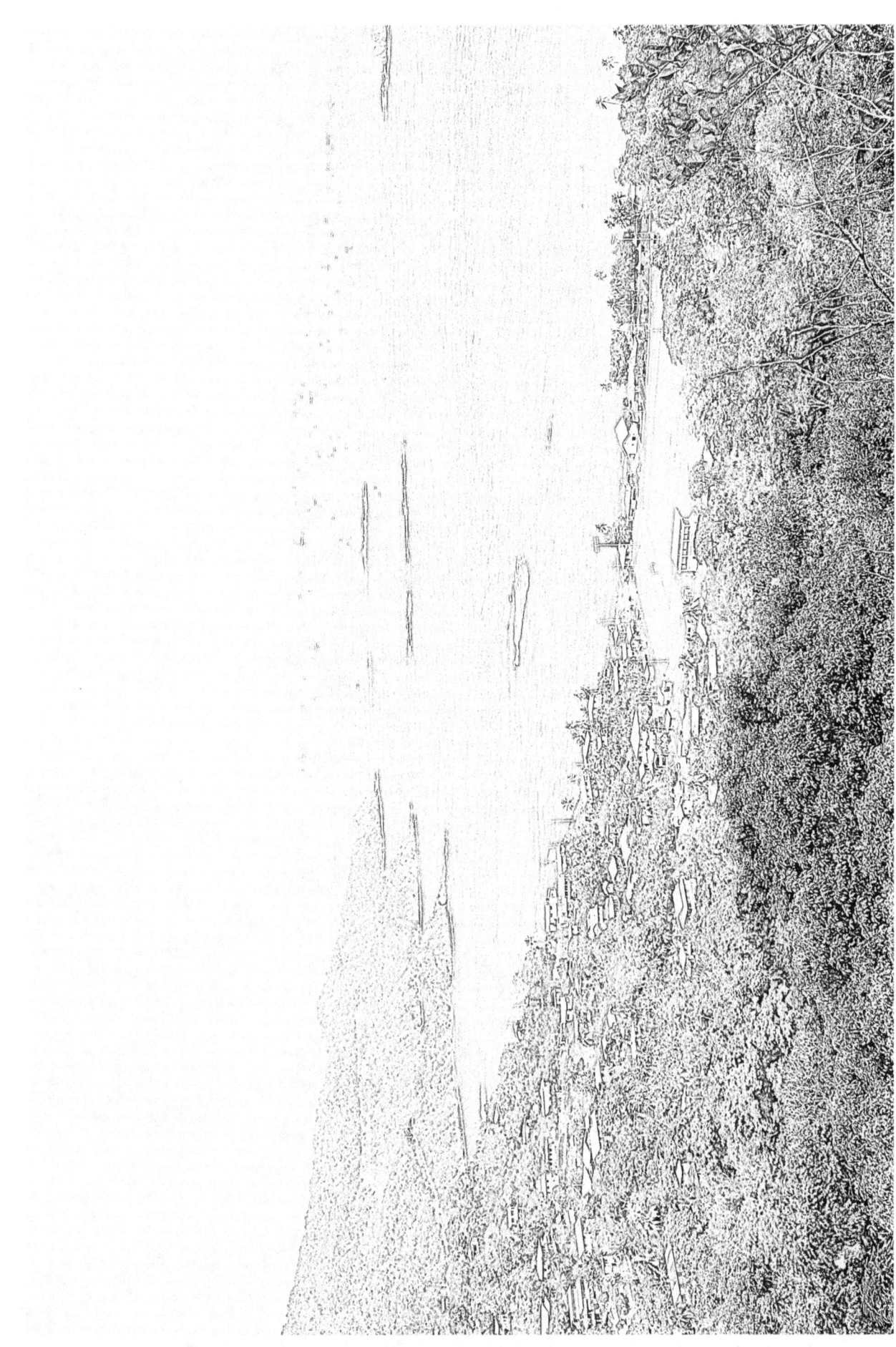

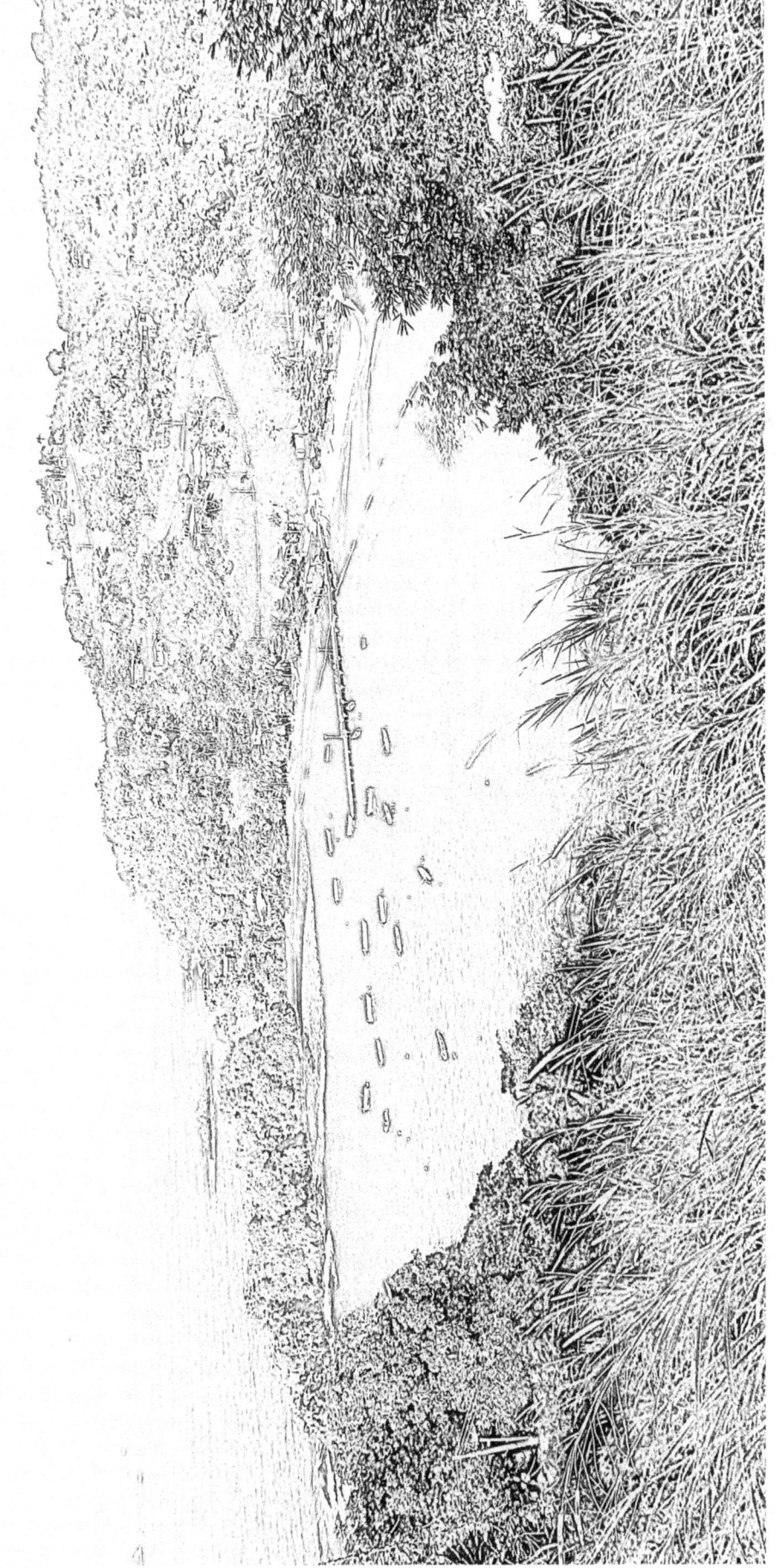

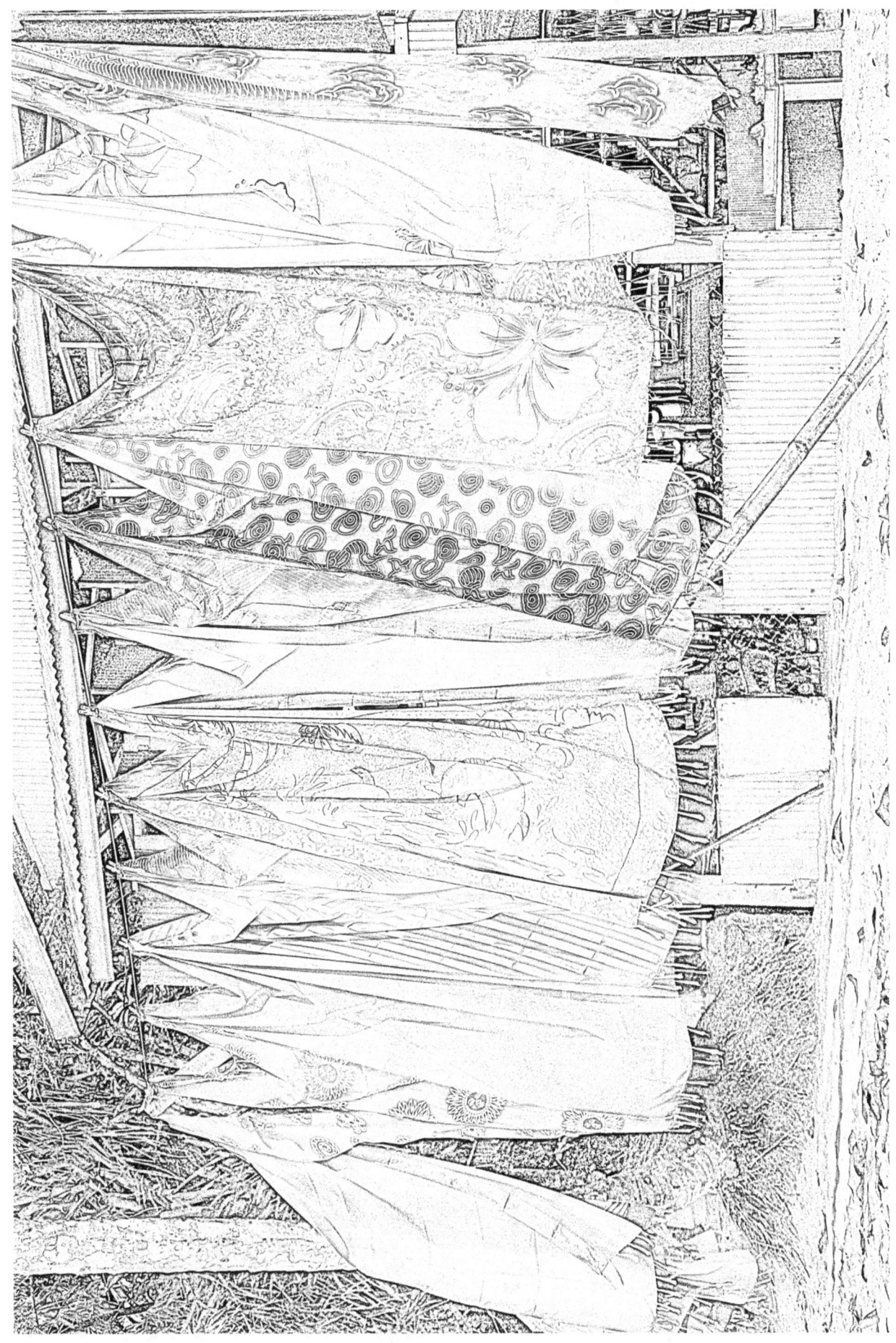

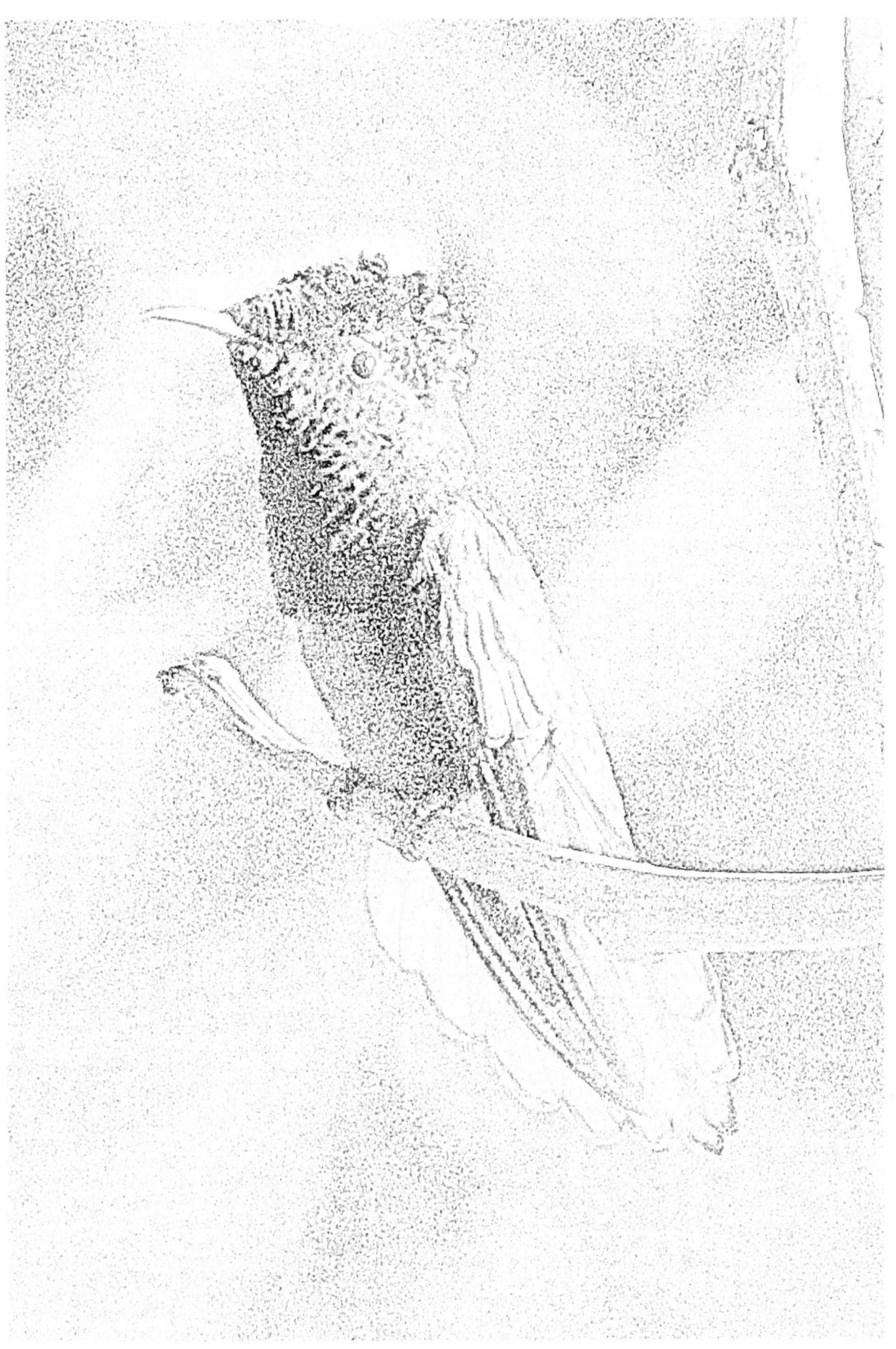

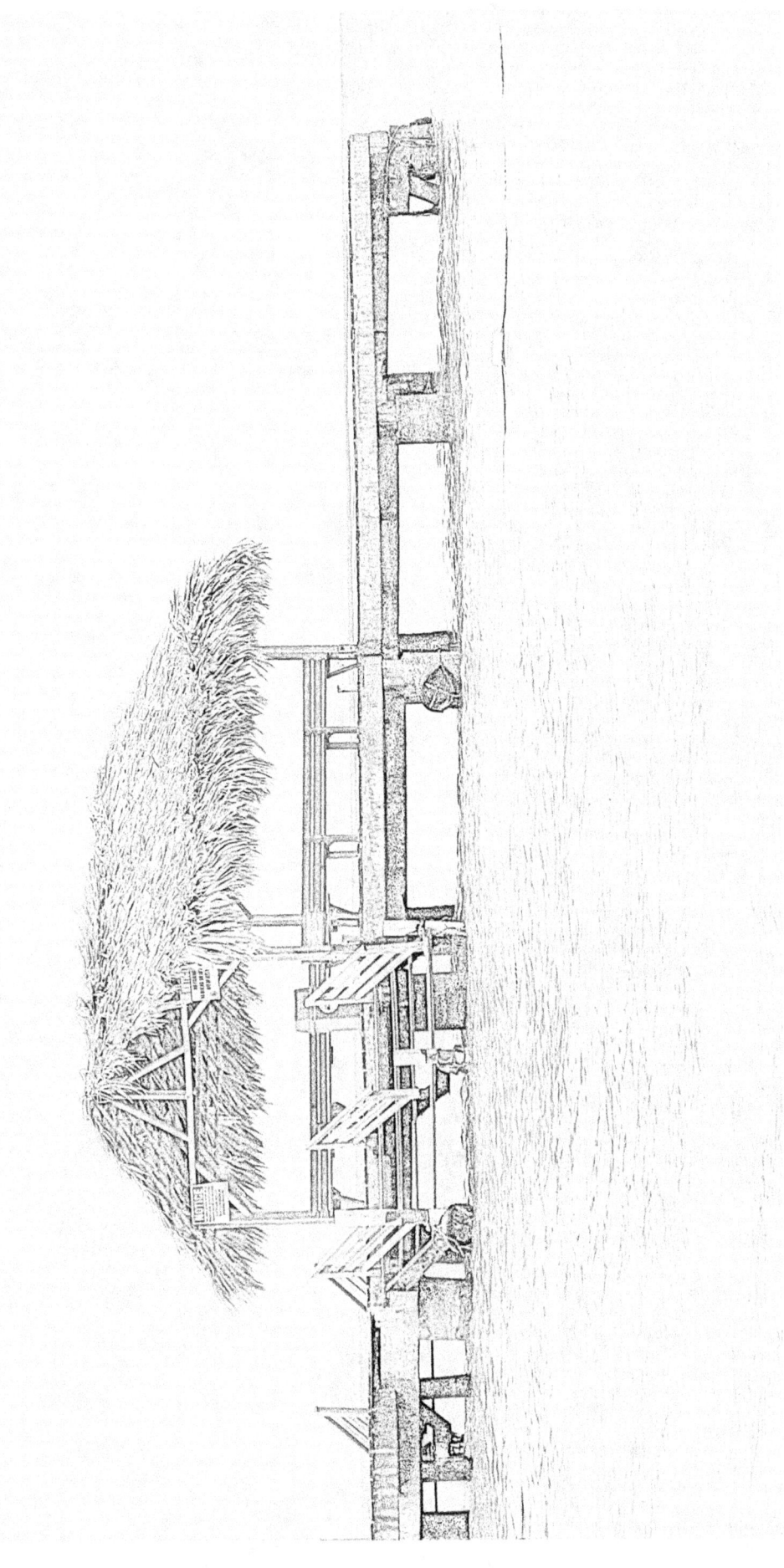

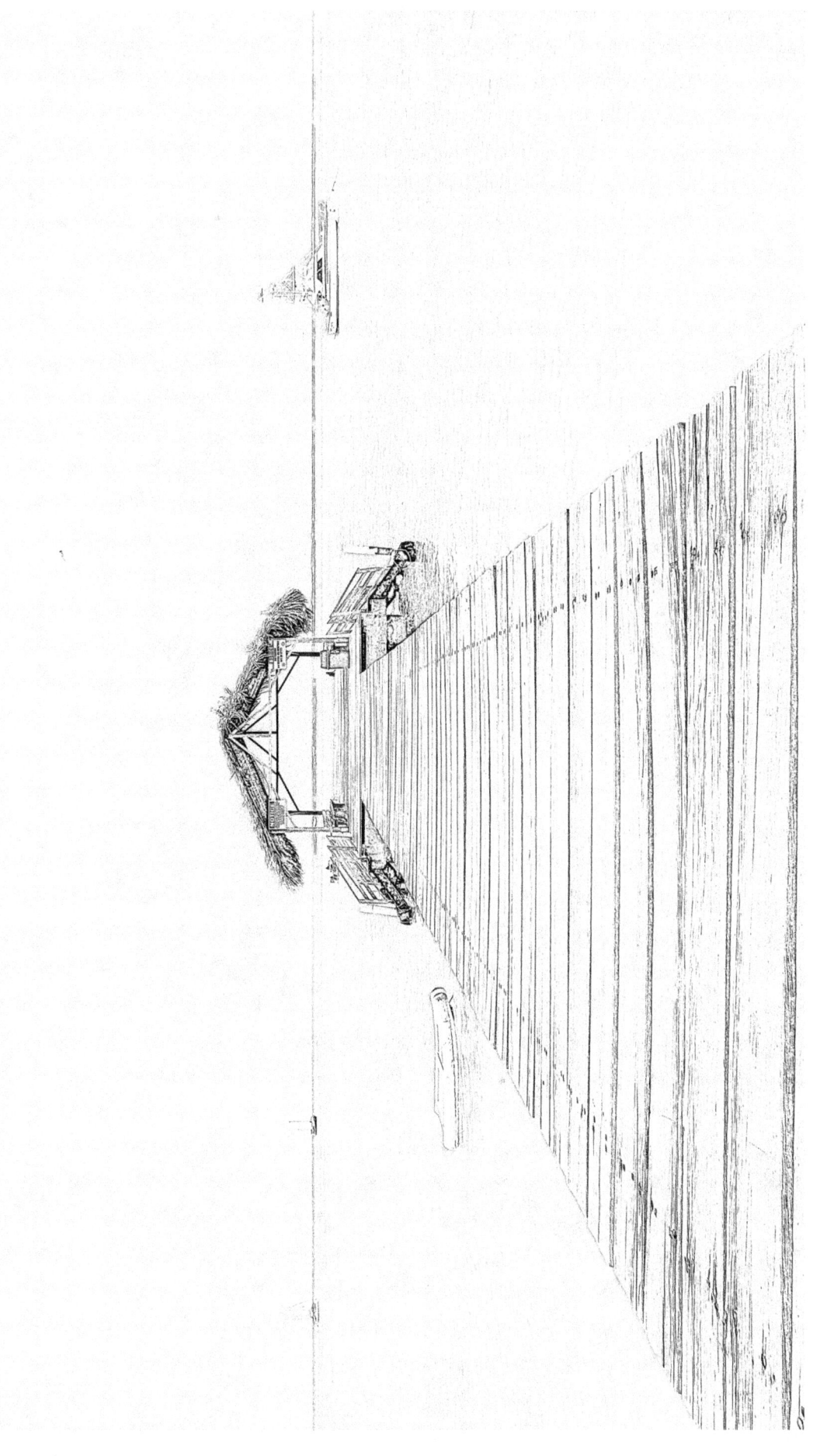

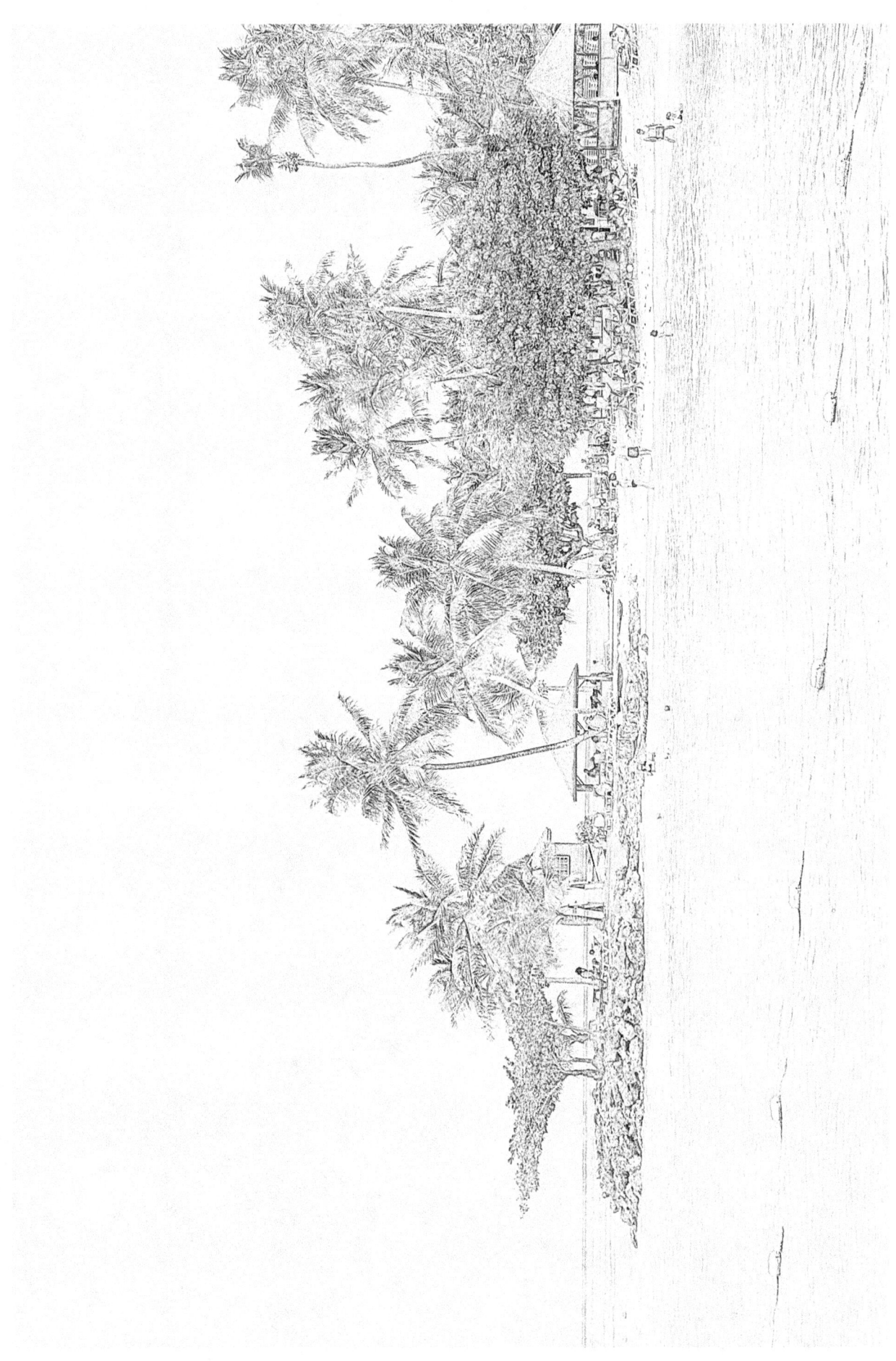

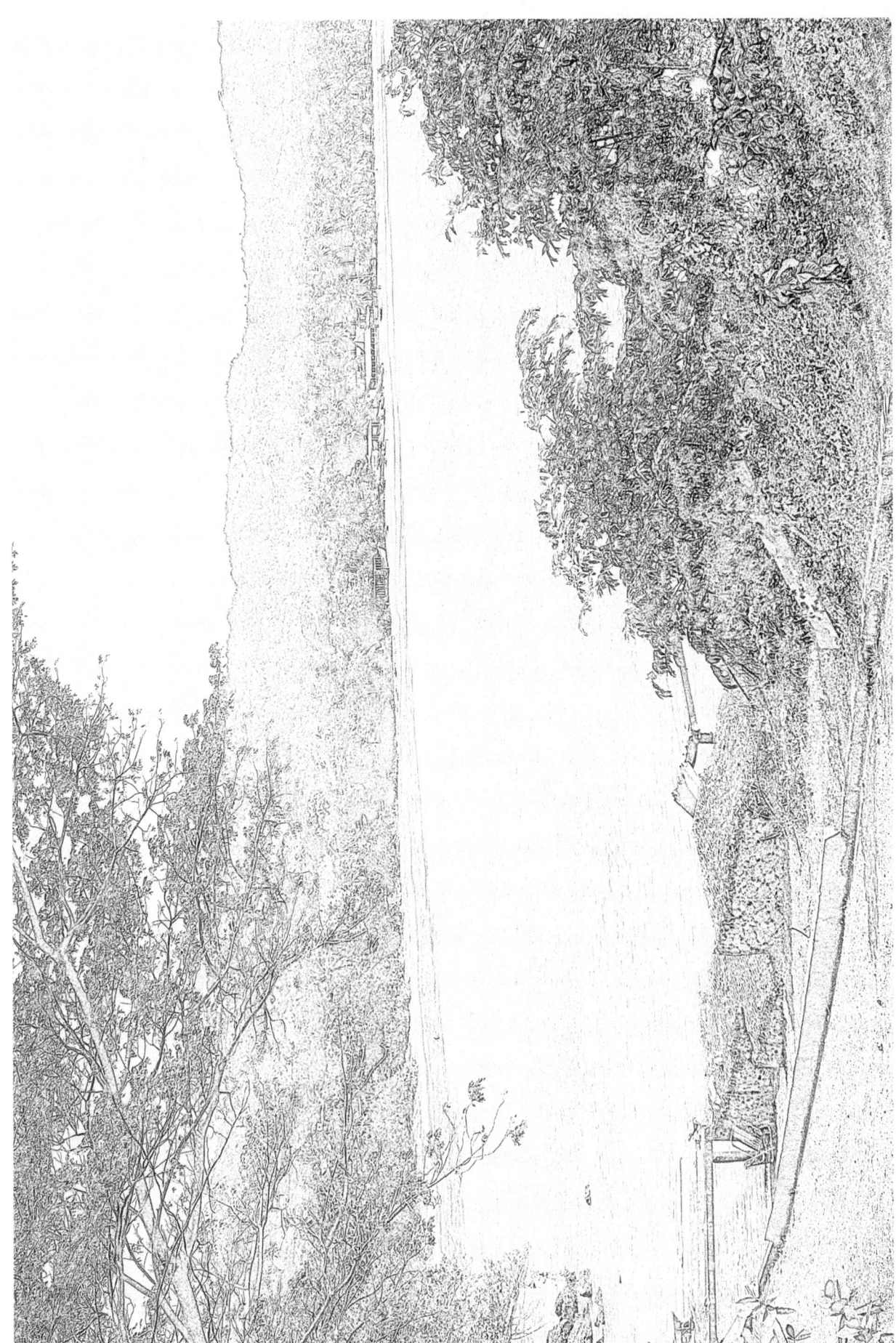

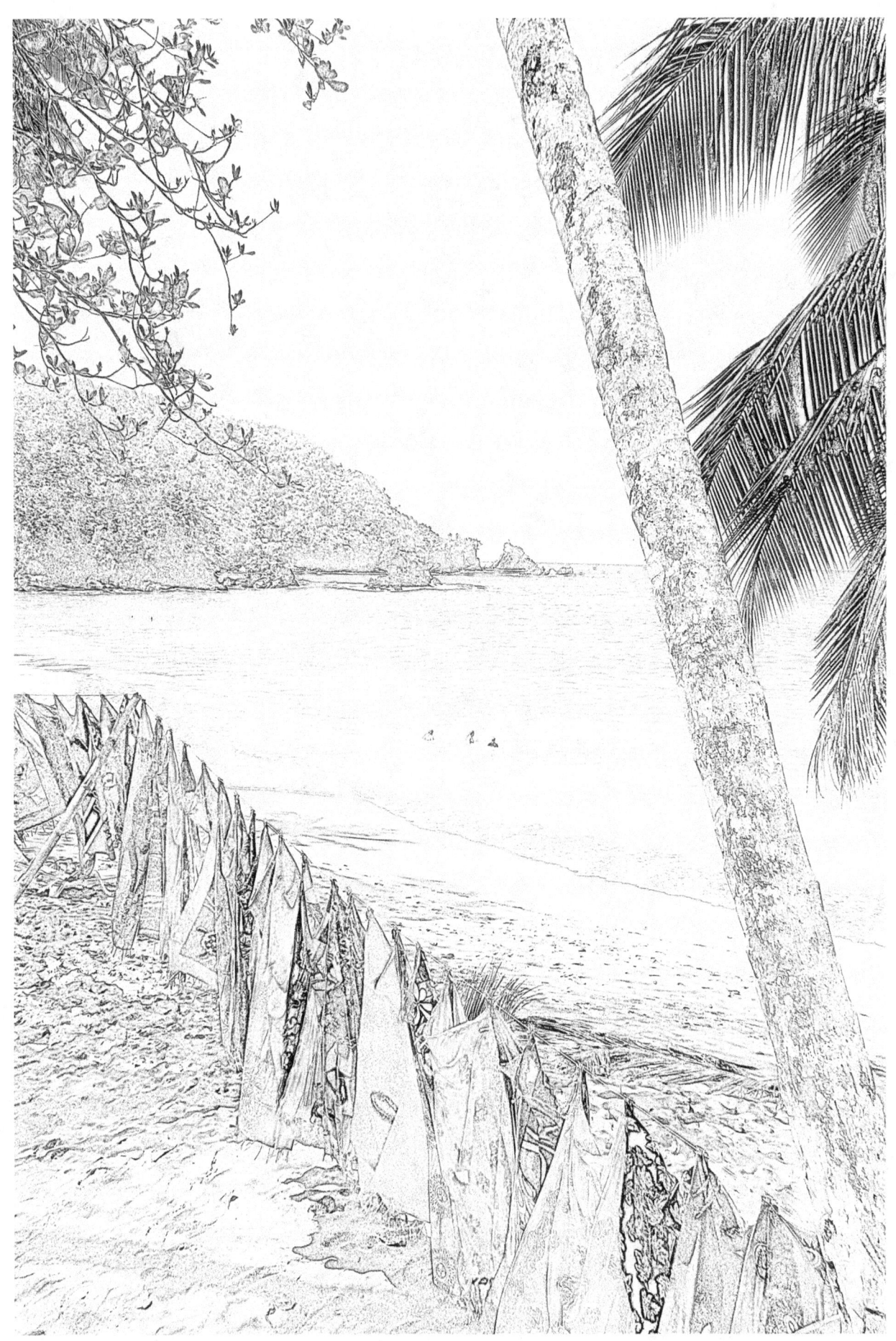

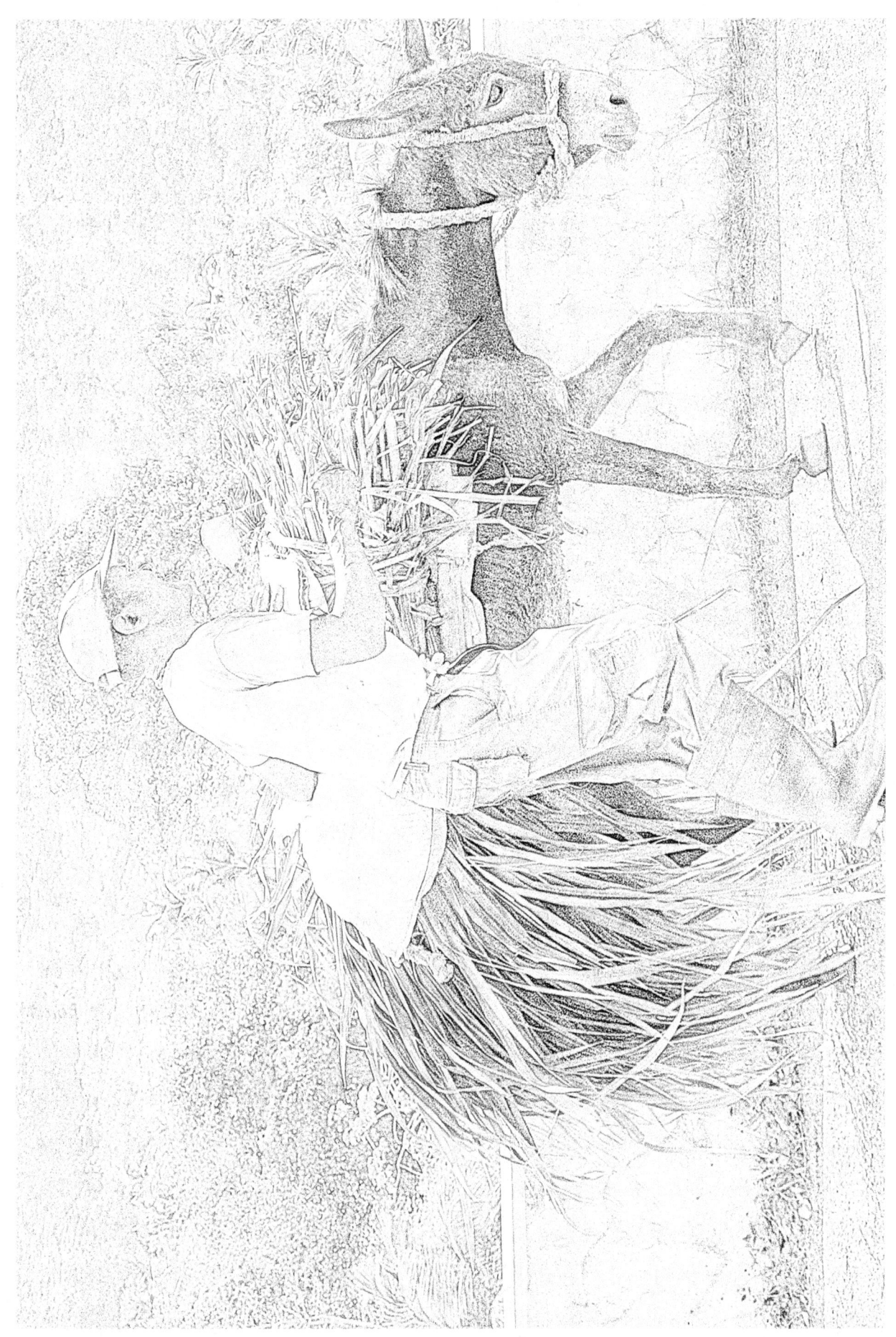

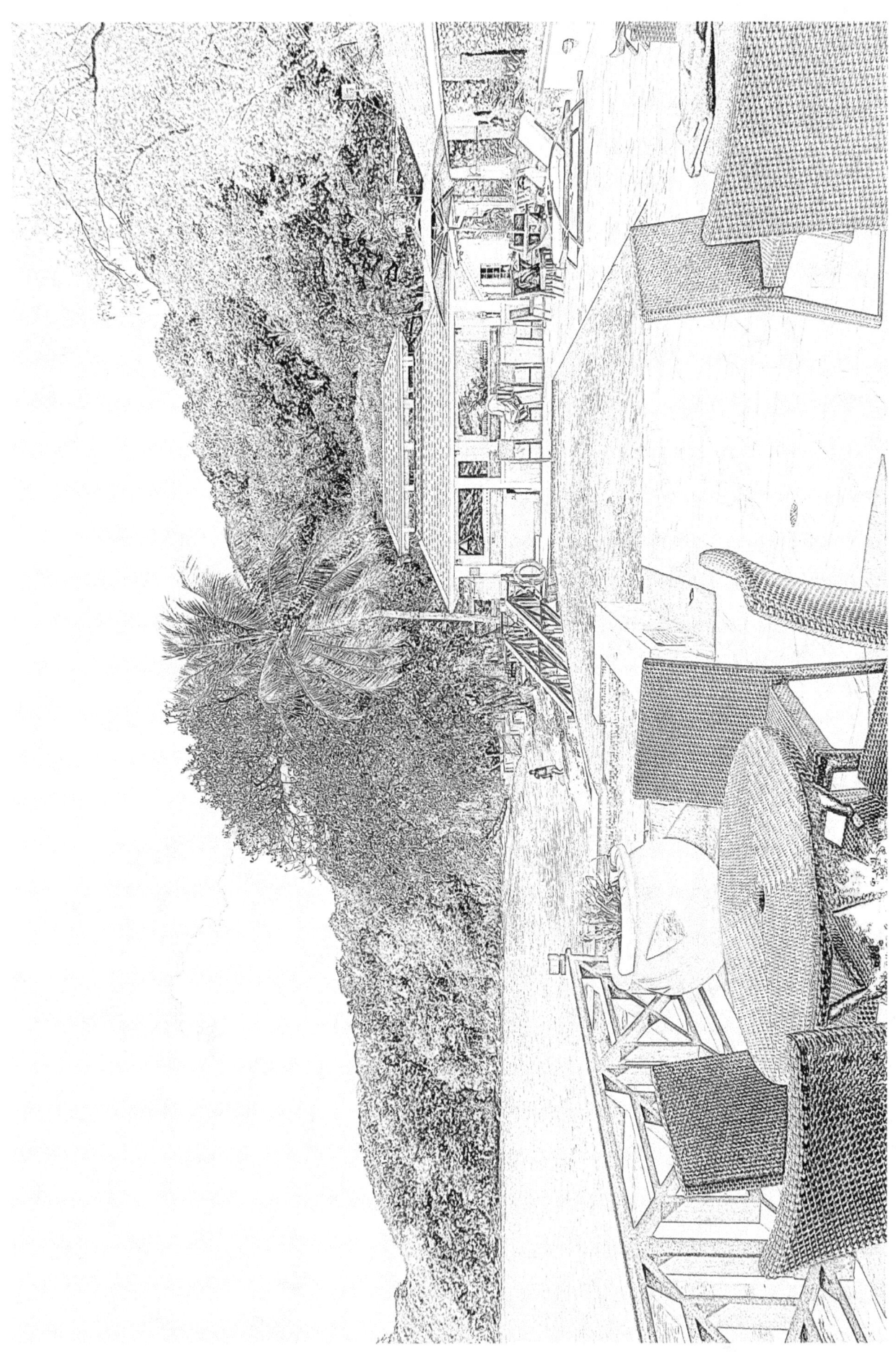

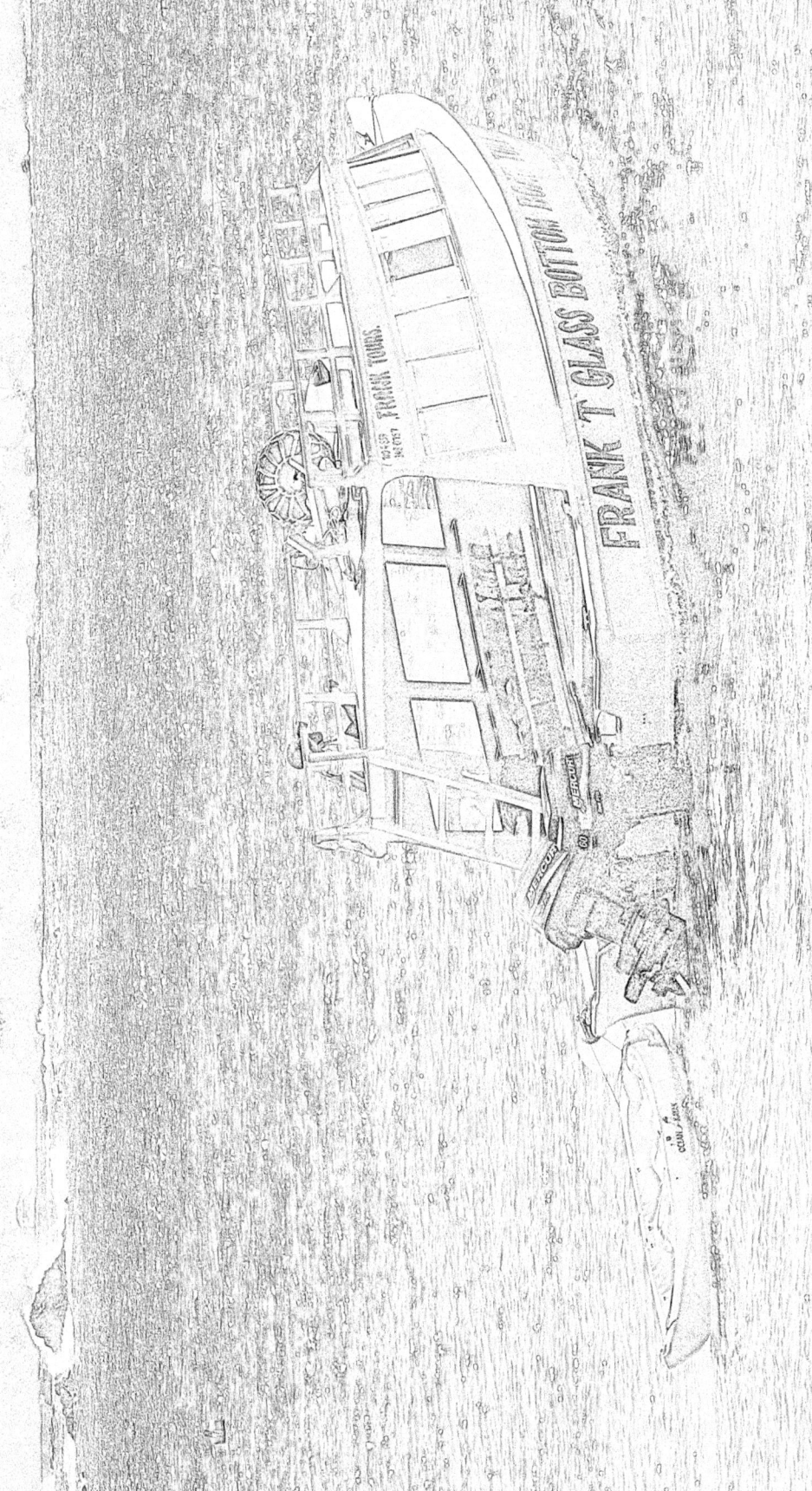

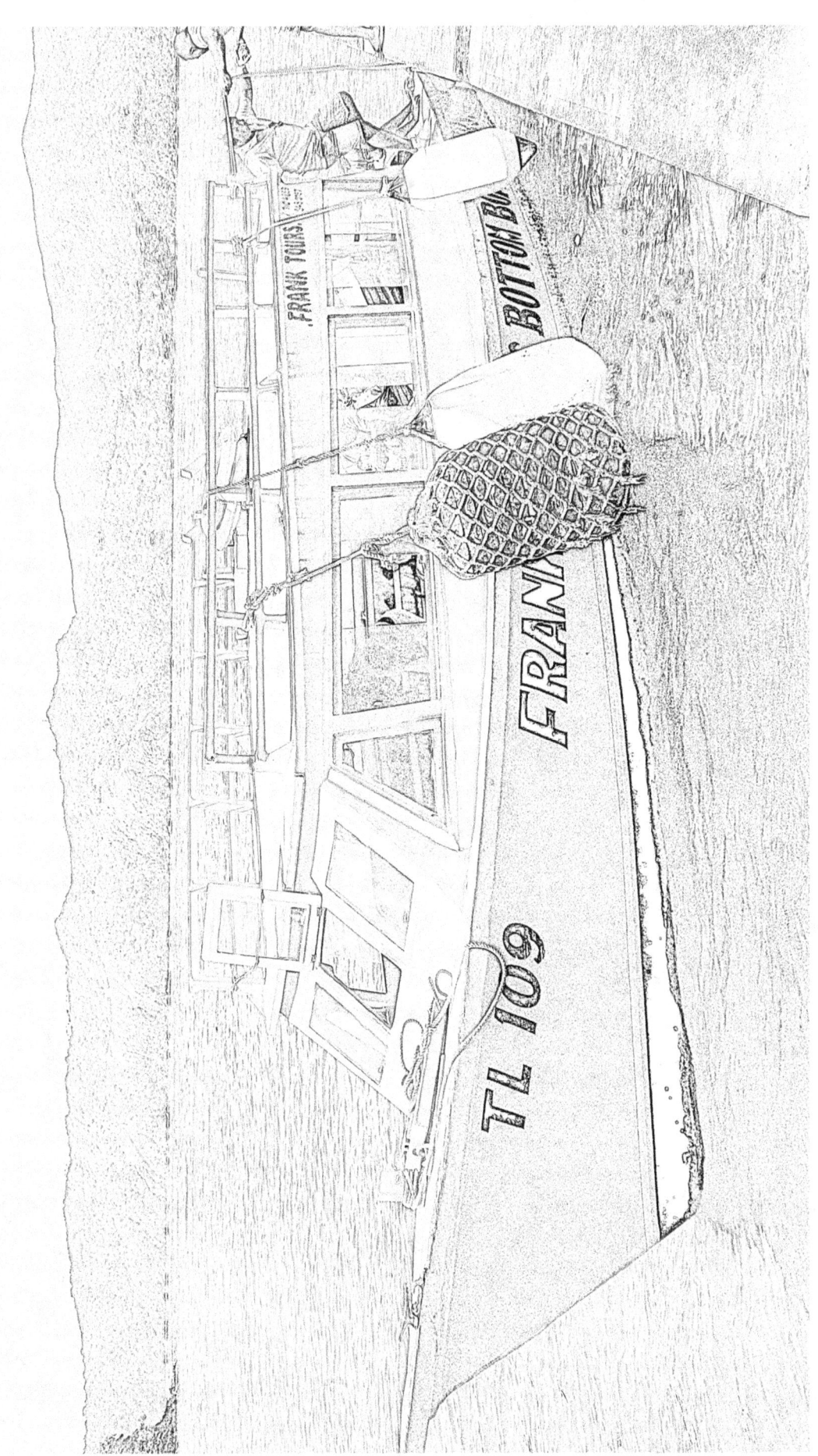

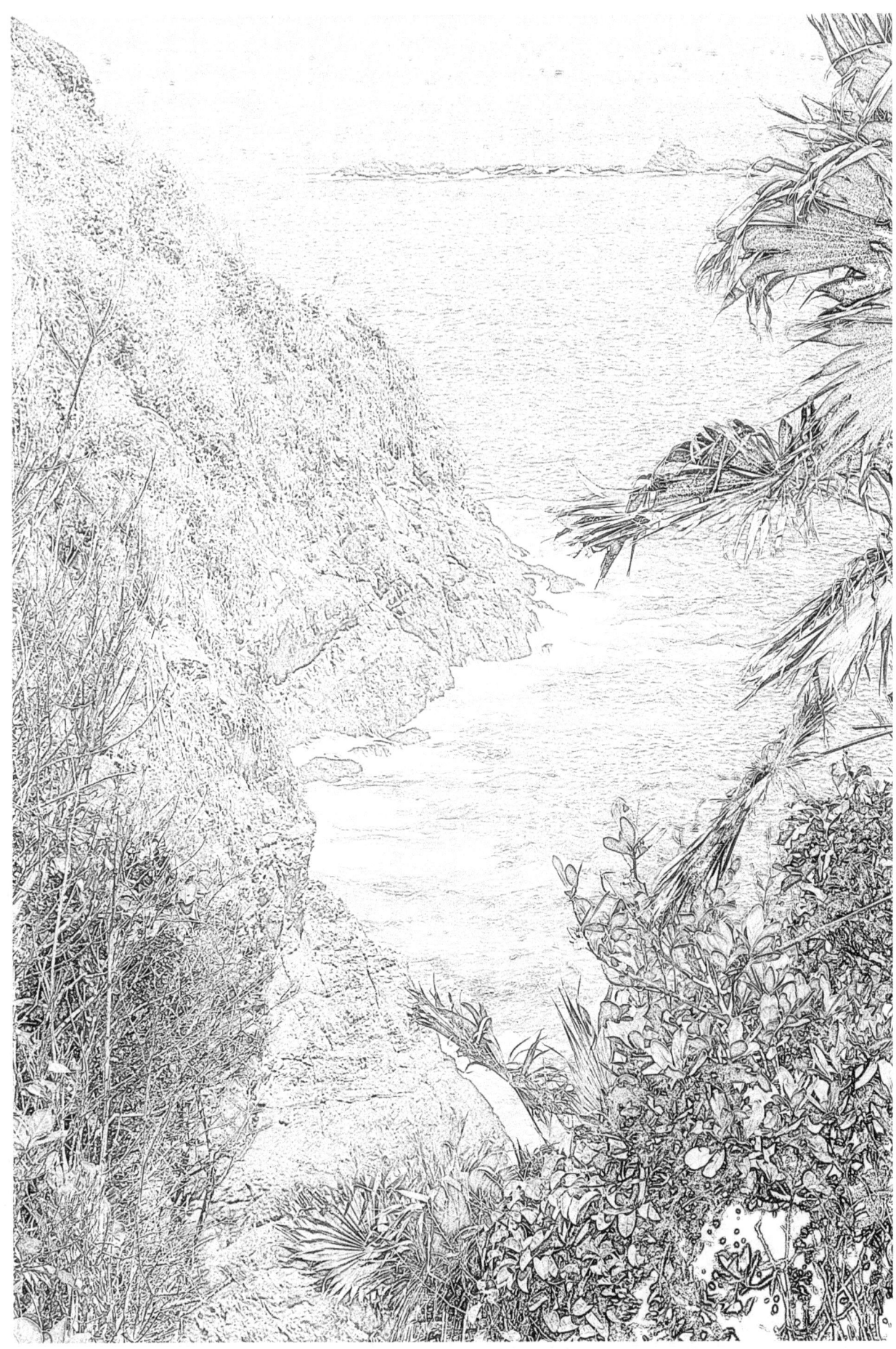

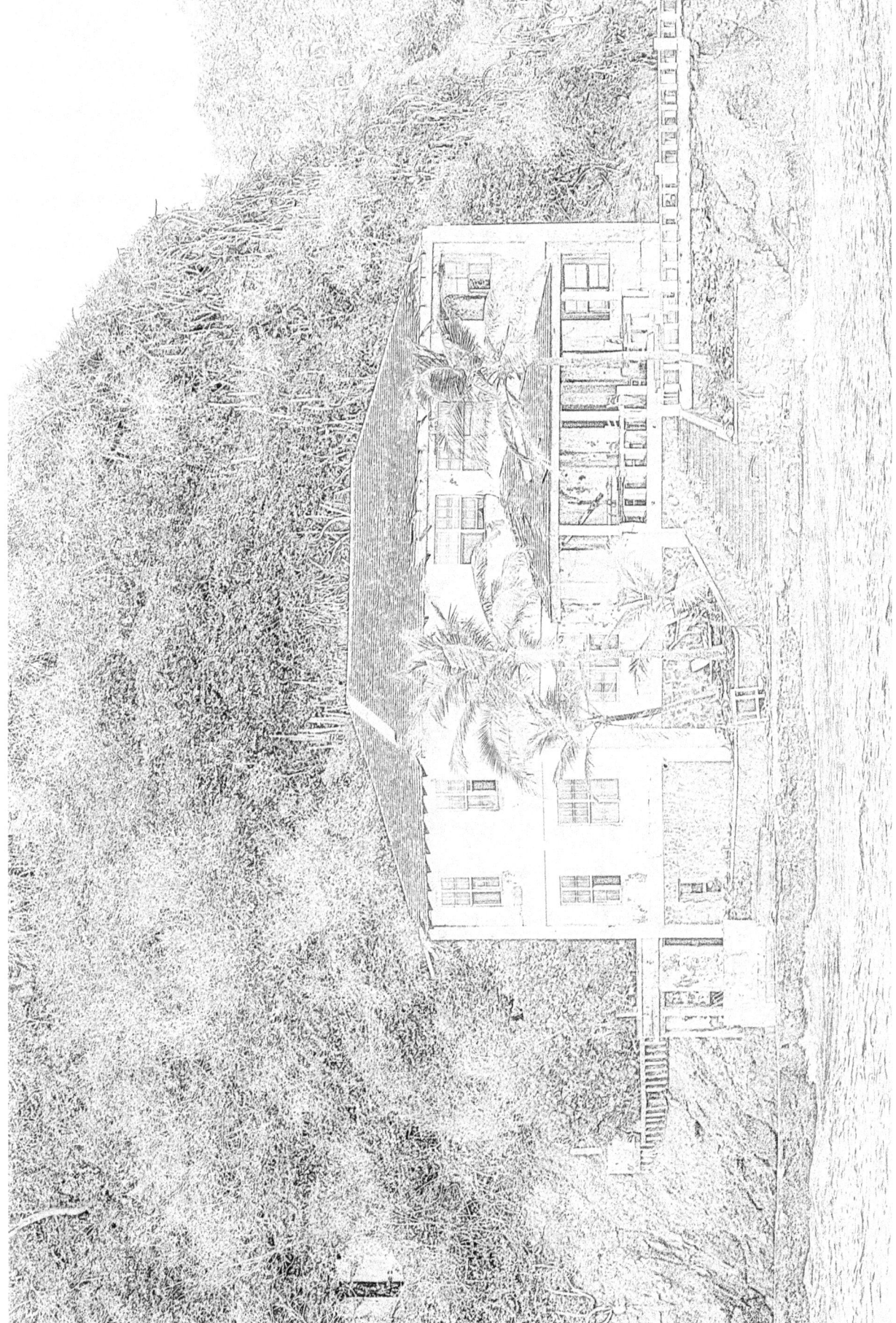

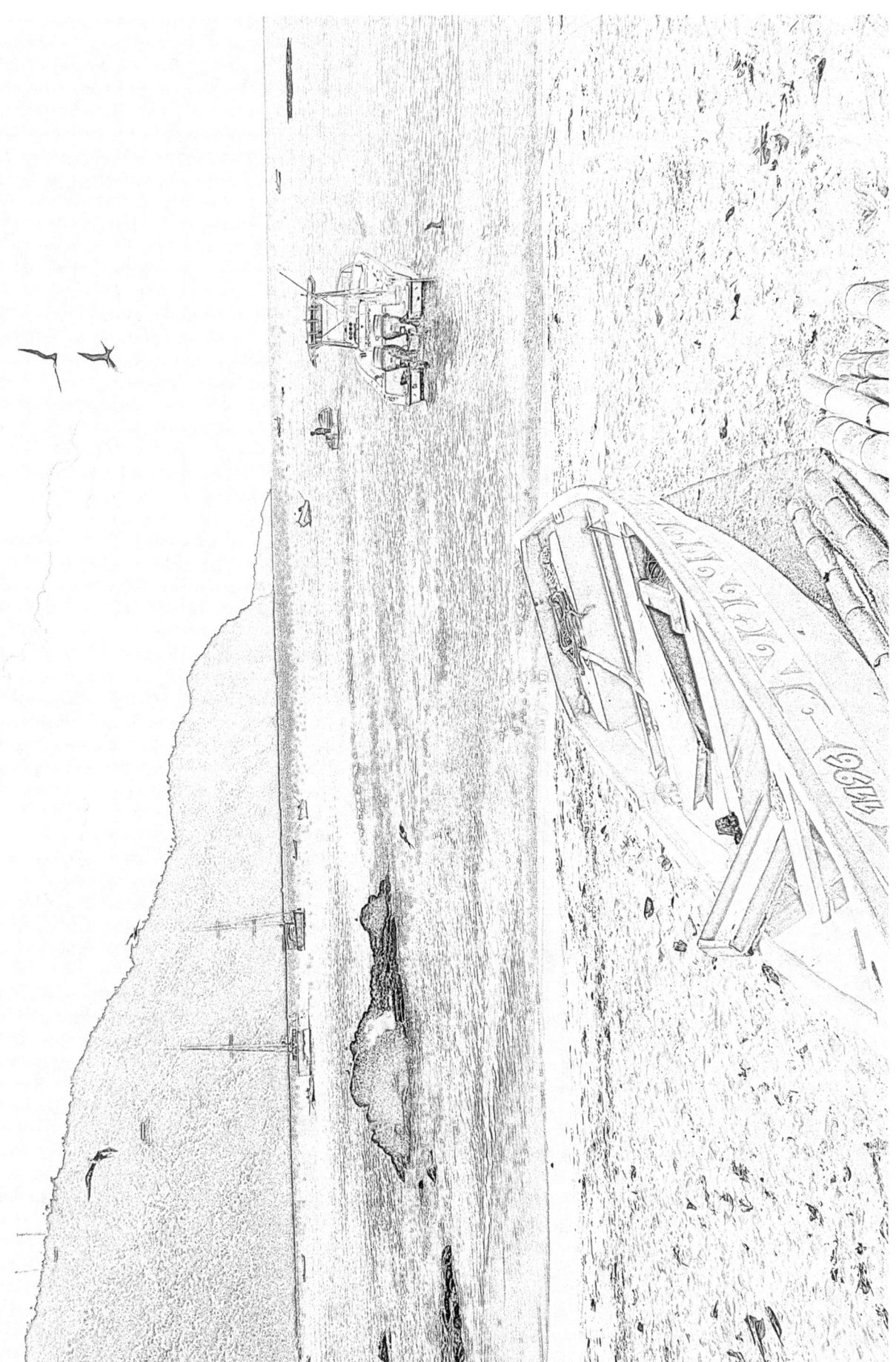

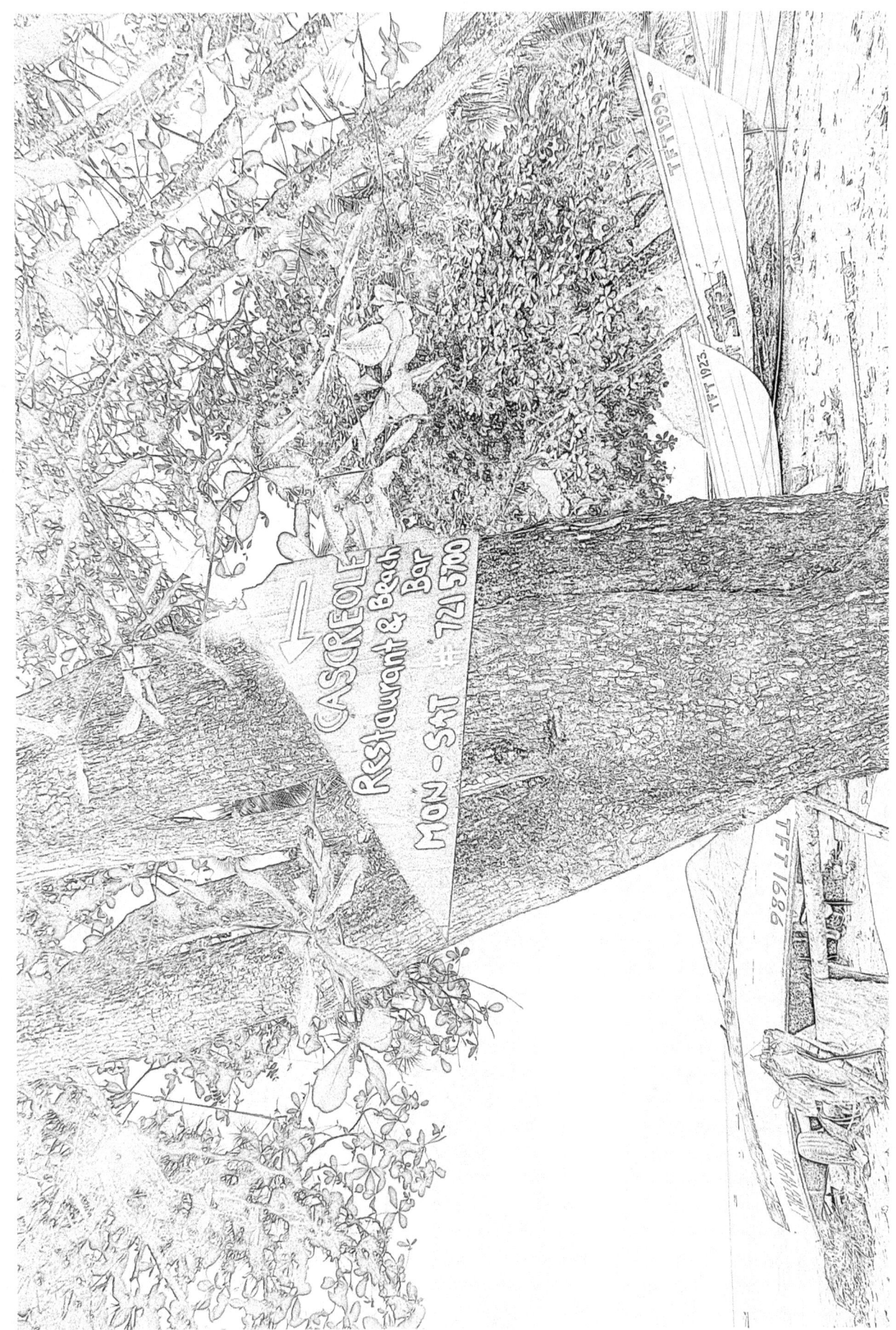

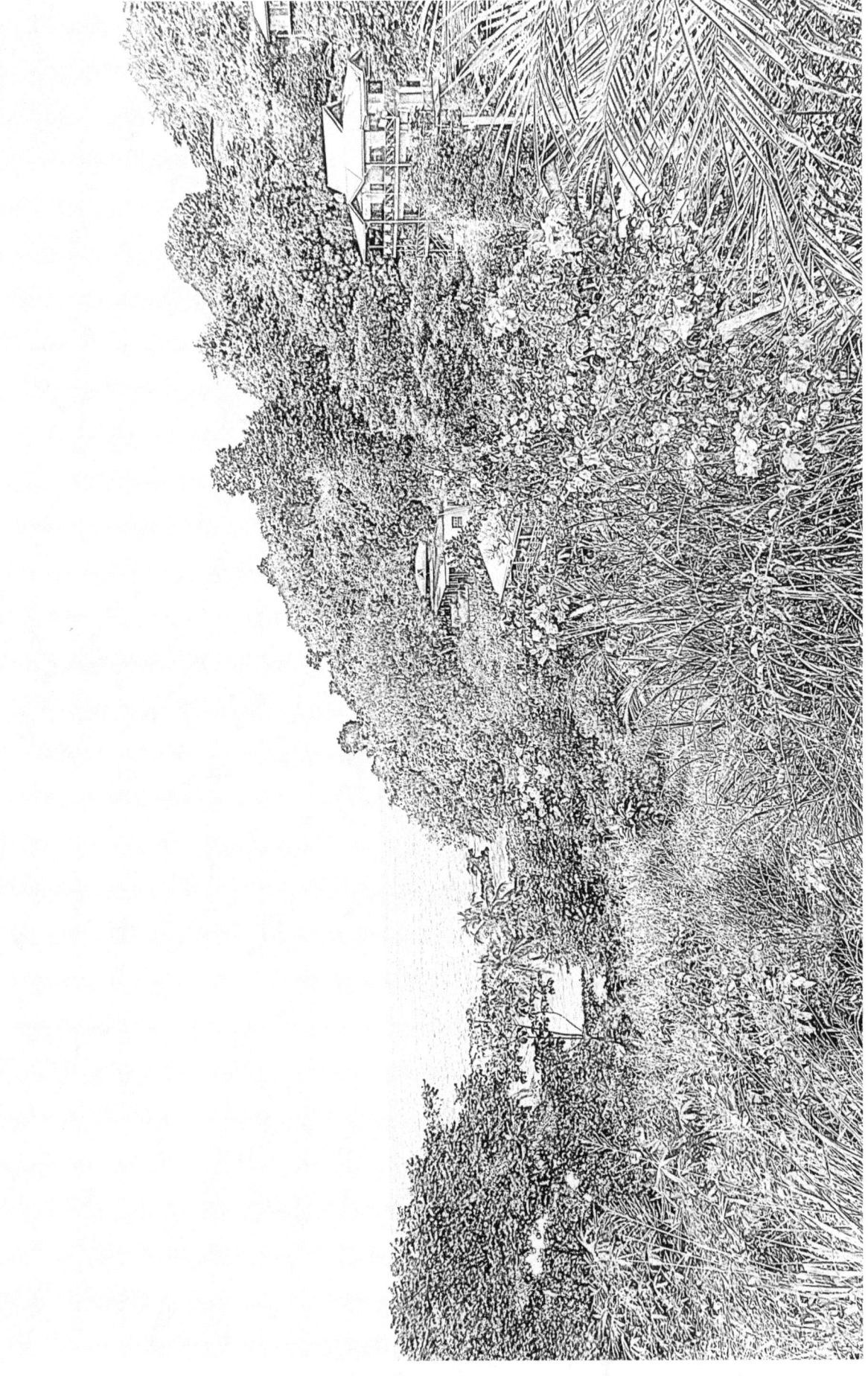

www.ingramcontent.com/pod-product-compliance
Lightning Source LLC
Chambersburg PA
CBHW080905220526

45466CB00011BA/3469